We INSPIRE me

We INSPIRE me

Cultivate Your Creative Crew to Work, Play, and Make

By Andrea Pippins

CHRONICLE BOOKS
SAN FRANCISCO

Library of Congress Cataloging-in-Publication Data available.

ISBN: 978-1-4521-6423-6

Manufactured in China

FSC
www.fsc.org
MIX
Paper from
responsible sources
FSC™ C008047

Designed by Kayla Ferriera and Lizzie Vaughan

10 9 8 7 6 5 4 3 2

Chronicle Books LLC
680 Second Street
San Francisco, California 94107
www.chroniclebooks.com

Chronicle books and gifts are available at special quantity
discounts to corporations, professional associations, literacy
programs, and other organizations. For details and discount
information, please contact our corporate/premiums department
at corporatesales@chroniclebooks.com or at 1-800-759-0190.

TABLE OF CONTENTS

Introduction

This is not a how-to book.

When I got the green light to write this book, I was totally thrilled. Here was my chance to bring together stories, essays, illustrations, advice, and tips related to the importance of building and nurturing one's creative community. After coming off a successful book tour, I was reminded how important it is to be surrounded by people who want to see you excel and thrive, inspiring me to share that message.

I have to admit, though, that once I sat down to write and draw I kept getting stuck. How do you really teach someone about building a creative community? We all know that strong, supportive, and inspiring relationships happen organically. You meet that one colleague who gets your obsession with vanilla lattes and instantly you two share daily coffee breaks, which soon buds into a dynamic professional relationship. Or you are seated at a dinner party and overhear another guest mention their upcoming trip to South Africa, where you have just returned from. You exchange email addresses so you can send them your list of recommendations. The next thing you know, you two

are linking up regularly to share other travel tips, and then you end up going on a trip together. You can't plan these kinds of things, nor can you force them. Special relationships like these just happen.

My intention here is not to teach anyone how to make a friend. Instead, I see this book as a resource to help you examine your network and learn how to utilize that group of people to find support, build community, and realize the power of that community.

But first let's define what it means to be creative.

You might have started reading this book and thought, "But I'm not creative." Um, yes you are. Every single person on this earth is creative. We've come to associate the word creative with people who paint, write, or sing. And yes, those activities do fall under the realm of creativity, but it's not because they're forms of art—rather, those things are creative because they involve making something from nothing. You imagine it and then bring your creation to life. The way we solve problems, how we express ourselves or connect with others, or put an outfit together—all of these are forms of creative expression. Whether it's through cooking, building a treehouse or a website, or planting a garden, we are putting our

mark on the world. And there are people with similar passions and interests who are ready to support us through those creative endeavors. There are tons of books and blog posts about creativity and what it means, so I won't belabor this point here, but please remember that being creative includes you. It's really important that you recognize this and that you connect with people who encourage you to cultivate your creativity in some way every day.

In nurturing our creative selves, oftentimes we need a community, a circle of friends, a tribe to support us on our creative journey. These can be friends and family we hold near and dear, who know our dreams, our secrets and short-comings. They can also be colleagues who help us navigate toward our career goals or virtual friends on social media who cheer us on through new projects or life changes. In essence, they inspire and guide us to offer the world our unique skills and talents. You get to determine the extent of your tribe, and this book will help you figure out how to do that.

I know you're super excited to move on to the rest of the book, but I'd like to share the intentions I had when writing it. First, it was important for me to highlight people who I truly admire and

respect—folks who are living out their creative lives. Throughout these pages, you'll meet some friends I've known for years and others I've only connected with virtually. Sadly, because a book can only be so long, I couldn't fit in all the people I wanted to feature. Even so, I think you'll find a nice range of ideas and perspectives from people across multiple disciplines and backgrounds.

Another intention in writing this book was to celebrate my own creative community. When I think about the growth of my blog, the artwork I've sold, and the books I've created, I know they were successful in part because of the people who have supported my creative endeavors over the years. Without them, I couldn't do what I do. In writing this book, I was constantly reminded of how powerful we are in numbers, how much we need each other to thrive, and how grateful I am to see this show up so often in my life and work.

Thank you, and I truly hope the following pages inspire you to live a fully creative life.

1

WE INSPIRE ME

*let's grab coffee

Creative inspiration can come from anywhere: a garden, a sound, or a texture in the pavement. We can be inspired by other people's work or ideas, especially if those people are members of our inner circle—the people who know us and who we connect with regularly. That's what I appreciate about the coffee or tea date. When I can, I carve out a little time to meet with a friend or creative colleague so we can chat about what's new in our worlds. Sometimes we bring a list of ideas we've been pondering or goals we're trying to achieve.

For a few years, two friends and I would meet every January to share our goals for the upcoming year. There was so much power in those meetings. We would talk through how we could help one another make our goals a reality.

At another coffee date, I talked with a friend about my dream of publishing a book. My homegirl was super excited about the idea and had some good insight and advice. She was so encouraging that I went home and immediately began writing a book proposal. It's crazy to think about it now, but years later—after several publisher rejections and some reworking of the initial concept—I would resubmit that proposal, which turned into the book you are reading today. And it all started with a friend being excited about one of my dreams.

It's in those instances that I am reminded that your crew is a great place to turn to to get your creative juices flowing and help you in your journey to live a full creative life.

GABI SMITH

is a cultural worker and designer who is constantly inspired by her creative family, which includes people from various disciplines and backgrounds. Gabi shares some tips on how we can all be inspired by our friends.

Stay Curious

Find different ways to cultivate your curiosity. Anything from taking notes, doodling, attending events, or creating a Pinterest board—whatever keeps you inspired and constantly learning. Whether you're part of one clique or a few, tapping into these groups of people for advice and inspiration and also sharing what you know can be a great way of keeping your curiosity flourishing.

Collaborate

Use collaboration as an opportunity to create in ways that you couldn't do alone. Building with others enables you to both share and learn from those you're making something new with. Having people around you who are able to view things from a different perspective is always a bonus and can really help you foster new ways of thinking.

Be Authentic

When creating anything, always think about the elements that need to come together to make sure it's as authentic as possible. What is it about the thing you're creating or learning about that interests you most? Why not reach out to your friends to see if they can connect you to the information or people you're interested in gaining more knowledge about?

It's OK (and Often Necessary) to Switch Off

The great thing (and not so great thing) about this current digital age is that we are constantly surrounded by information, which can leave us feeling overwhelmed and burned out. Sometimes the best thing you can do is to switch off or find new ways to add self-care to your creation process. Is there someone in your inner circle who you trust to be an accountability partner? How about creating a group "detox challenge" where you and your friends dedicate the time you would've usually spent online to learning a new skill, discovering new places (without Google Maps!), or simply relaxing and taking care of yourselves.

Don't Be Afraid to Share

Don't let other people's fear or lack of understanding of what you're passionate about be the reason you don't tell your story. Sometimes, your job isn't to convince others—it's to find the people who value your story and what you have to share. Having a supportive crew will give you the self-assurance to keep going.

Don't Wait to Be Asked

Some of the most fulfilling opportunities you'll experience will come from taking the initiative to put yourself out there and create what it is you want to see. On the surface, this can feel daunting, even if you've done it many times before. Touch base with the members of your creative network: Have any of them dealt with the same issue? While the initial effort is something that comes from you, knowing others who have been in the same position can lessen your fear and the expectation of waiting to be asked before moving forward.

host a salon

What is a salon, you ask? Generally, a salon is a gathering, usually in someone's home, where like-minded folks come together to talk, share ideas and new work, and just hang. Salons are great ways to be inspired by your friends (or to make new connections). Here are some tips for hosting a salon.

spark a discussion

Bringing guests together for a conversation is an engaging way to spark new ideas and give insight on what's happening in the world. As the host, you can have a list of topics ready to go or invite one of the guests to introduce a topic.

critique work projects

If you have writers, designers, or artists on the guest list, invite them to bring their recent works and allow others to give feedback.

have a special guest

If you have an influential friend or colleague in your clique, invite them to speak about their skills, interests, or talents with the group.

meet regularly

By meeting on a regular basis, guests can build on the relationships established at the salons and feel they have a safe place to go for inspiration.

find the perfect blend of guests

Have like-minded people on the guest list, but make sure there's also a diverse group of interests and backgrounds so folks can learn something new from one another.

create an inspiring atmosphere

Keep artwork visible and coffee-table books and curiosities handy. They all make great conversation starters.

Nicole Haddad

is a fashion designer who draws creative inspiration from her Brazilian culture and friends. She gives us some DOs and DON'Ts on using one's community for creative support.

Celebrate your people.

It's important to be happy for the successes of the members of your creative family. You move ahead together, so their success is your success!

Share.

It's good to be open about the challenges you are facing with your creativity or your process. It's amazing what a different perspective can bring to the table.

Collaborate.

You can't get anywhere all by yourself. Be open to working with and learning from others.

Be inclusive.

Work together to share your resources. It will help everyone progress with their work.

Be honest and up front about your personal objectives.

Not being transparent can make people skeptical of your motives.

Be respectful of other people's work.

Make sure that you're not stepping on anyone's toes or subconsciously using their ideas.

Compare your progress or your work with that of your friends.

Appreciate where you are and use others' successes as a motivation for your own work.

Use people.

Everyone should benefit from collaboration. Users get a bad reputation quickly!

Take people for granted.

Even your most fervent supporter will get tired of helping you with your vision. Make sure you are equally supporting their vision or their goals.

Rush into relationships.

Just because you like someone doesn't mean that you will work well together. Be wary of partnerships!

Give all your secrets away.

Sharing with your crew is fulfilling and supportive, but remember that you have worked hard to learn your craft and you should keep some information to yourself.

HOW CAN I support YOU?

My inner circle is made up of a lot of different kinds of people, but mainly artists and entrepreneurs who are exploring uncharted territory with their work. Some of us are trailblazers, others work completely on their own, and others have started new ventures or projects after years of doing something else. Which is why asking how you can support them is so important.

Pursuing creative endeavors, whether as a hobby or a business, can sometimes be difficult. We get distracted with other tasks (like administrative work or just cooking dinner) and can feel discouraged. That's where the gang needs to step in. Think about how you want to be supported in your work, your dreams, and offer that same support to your friends. Don't assume you know what that person needs; ask them what they need to feel supported and offer help if you can.

ways I'm inspired by friends

Seeing my friends thrive and navigate their individual paths is always inspiring. If I'm stuck, I look to them for motivation or mental stimulation. Here's what I look to:

their journeys

pursuing their dreams

breakthroughs

successes

feedback

artistic creations

aspirations

Bernardo Margulis

This designer reflects on how a special personal project led him to some unexpected connections and creative opportunities.

I STARTED *This Makes Me Happy,* a podcast about people and what makes them happy, as a passion project.

I was unhappy with my job and living in New York City, so in the summer of 2013, I moved back to Philadelphia to start a design practice and pursue happiness. I called my business This Makes Me Happy as a constant reminder of my mission. Mentioning my company name invited others to share their happiness stories—it started with talking about what I do, and led to sharing inspiring anecdotes about the pursuit of happiness. After a couple of years of hearing these stories, I decided to turn them into a podcast, and now I talk all the time with people about what makes them happy.

If you research how to start a podcast, you'll likely read about building an audience and monetizing the show. While the podcast wasn't my why, I figured, sure, it wouldn't hurt to get into the iTunes Top 100, reach thousands of downloads, and find sponsors. I quickly learned two things: Podcasts that successfully monetize are the exception, and having a podcast is a great way to strengthen my creative relationships. Having a community has always been important to me, and I'm happy this side project has helped me nurture it. In the end, that's turned out to be way more beneficial than turning it into a moneymaker.

Asking people what makes them happy gives me a reason to reconnect with old friends or approach people whose work I follow and admire. My friends and guests introduce me to other people they think would be a good match for the project. I even have people asking to be guests who wouldn't even know about me without this project.

Because I seek diverse guests, I meet people from all over the world with different backgrounds. I interviewed a Chabad rabbi in Brooklyn on how having a sense of higher purpose and service makes him happy. I spoke with a writer and entrepreneur in Bulgaria on how new beginnings make her happy, and I met with a crochet artist in Australia to hear about how he enjoys meeting new people. These are just a few of the wonderful conversations I've had.

Sometimes I connect with people for only that one conversation; others come back into my life in different forms. Shortly after recording with a woman in Germany, we jumped onto Skype so I could help her with InDesign, a software program. My friend Rachel lives in Los Angeles, and the podcast became a catalyst for us to support each other's content creation. My sister introduced me to author Ben Kassoy, and after our recording, he invited me to participate in a couple of artist collaborations. Because of my podcasting experience, I now lead a series of interviews with prominent designers for a design organization in Philadelphia.

Having a podcast where I ask people what makes them happy has been a very rewarding experience. Recording an episode or getting listener feedback makes my day. The topic fills me with joy, but the most exciting part is that I get to connect—or reconnect—with people who enhance my creative community.

"So many members of my tribe serve as my muses."

—Lorraine West

Jewelry Designer Lorraine West shares how her tribe inspires her creative life

Lorraine West

You're an artist and jewelry designer, but you started in illustration. Tell us a little about that transition and how your friends supported you during that time of creative change.

I started teaching myself how to create original jewelry during my junior year at the Fashion Institute of Technology (FIT). At the time, I had no intention of it becoming anything more than another creative outlet outside the demands of my illustration studies. My friends, who also attended FIT and the School of Visual Arts (SVA), were always supportive and some of my very first customers. They wore my work as if it was the best stuff on earth. The support of my community helped to build my confidence and faith that more people would take interest in my work. The rest is history. I've been designing and selling my eponymous jewelry line ever since.

How does your creative community inspire your creations?

My creative community inspires my creations daily. So many members of my tribe serve as muses. I get feedback firsthand, whether it's about ways to improve my business or suggestions to expand my collections based on their favorite items from my prior collections. The best part is seeing my community wear my designs for their everyday armor and for the most important milestones in their lives.

Can you tell us about how your tribe has helped you get unstuck or overcome challenges?

I am blessed to have such a diverse group in my creative family; it consists of artists, musicians, designers, directors, publicists, life coaches, writers, urban planners, and healers. They've inspired me to pinpoint the areas in myself that needed change in order to have sustainable growth in my business and personal life. The major takeaway I've learned from my tribe is to honor myself and the rest will follow.

Any advice or tips on how to support your friends in their creative endeavors?

If you love your friend's work, then support it yourself and spread the word. Collaboration is also a great way to support one another's journeys. Two heads (or more) are better than one. If someone within your creative crew feels discouraged, lift them up, remind them of the reasons why they must press on. Be honest, be present and loving to yourself and to the people who support you.

2

Your Career Circle

*hello my name is...

When I was a senior in college and about to graduate

with my BFA and a freshly curated design portfolio, I received the best advice from the professor of our senior design class. With a serious but kind voice, he told us how important it was to show our portfolio to anyone who was willing to look. He encouraged us to reach out to people, whether they were hiring or not, to ask for constructive feedback about our work. That summer, a few months after graduation, I moved to Brooklyn on a whim (and without any job prospects) and took his advice to heart.

For months I emailed, cold-called, and met with anyone in the design industry who was willing to take the time to look at my portfolio. From the hot and sticky dog days of summer through the chill of early winter, I lugged that huge portfolio case all over Manhattan and some parts of Brooklyn.

It was an exhausting experience, but it taught me a lot. Meeting all those different people allowed me to practice presenting my design work while also making a ton of professional connections. Eventually, all of that portfolio lugging paid off. Granted, it was some time later—after I had already moved to Kansas City to work

at Hallmark Cards—but because of the connections I made, I landed a full-time gig back in New York at TV Land/Nick at Nite.

No, all of the people I met with did not become friends or a part of my immediate tribe, but all those informational interviews did give me the confidence to navigate professional situations and make connections with people at professional events like conferences and happy hours. Because of that experience, I wasn't afraid to introduce myself to anyone, which ultimately made it easier to meet people who would later become a part of my inner circle.

be a mentor

Do you have a mentor? It's worth reflecting for a moment on all the amazing things a mentor can do or has done for you—from connections made to hard lessons taught. I've come to realize that one of the best ways to expand one's professional network and give back is to become a mentor yourself. It's a great way to teach, but also helps us grow. Of course, as we navigate our professional lives, meeting industry leaders and peers is important. But there's something about young people—their fresh take on problem solving and their enthusiasm and their dedication are inspiring. Sometimes it can be intimidating to think about the act of teaching, but you likely have more wisdom to share than you realize. Here are a few ways to make those connections through mentorship.

Write about experiences

Whether it's through blogging or submitting an essay for a publication, sharing how you got to where you are professionally is always inspiring. It gives others, especially people who are trying to pursue a similar track, insight into what it takes and motivates them to figure out what's right for them.

Host a workshop

Yes, workshops do require some planning and prep work, but there's something so fun about being able to develop your very own course that allows you to share your experiences. You get to determine all the specifics, such as the audience, the course outcomes, and the curating of a space for learning.

Speak at Schools

Workshops are great, but if you don't have that much time to develop a curriculum you could also speak at an educational institution. You still get to speak with young people in a more casual setting but without having to create coursework. And depending on your comfort level, you can have a big platform (like an auditorium) or something small and intimate (maybe a classroom after school).

Be available

If you are looking to give guidance to young people or are already a mentor, don't forget to be available for questions and feedback. Whether it's in the form of an email or a coffee date, make time for that person who is seeking your help.

introduce to your network

Meeting one-on-one is necessary to develop a relationship, but connecting a mentee to your network is a great way for them to get to know other potential mentors or see other examples of professionals. Invite your mentee to an event or meeting so they can experience in real time how to interact with others in those unique settings.

MAORI KARMAEL HOLMES

Filmmaker and founder of the BlackStar
Film Festival, Maori Karmael Holmes, shares
how her community supported her during
a rough patch of unemployment.

I HAVE DISCOVERED that I actively maintain three circles of support for my professional life. The inner ring is made up of very close friends who are equal parts ambitious, creative, intelligent, and talented. All of them, like me, are also multihyphenate generalists, meaning that they transition easily between careers, hobbies, and side projects. The middle ring is much larger and consists of a diverse group of fantastic people who I call upon for specific aspects of professional support, such as résumé proofreading, human resources advice, emotional coaching, big-picture strategizing, or political finesse expertise. The outer ring is composed of associates and colleagues who offer support in the form of job feedback, personal connections, and encouragement. I am quite certain that many people maintain the same concentric rings, as I find them necessary for the varying needs along my career journey.

I had always prided myself on my ability to interview well and land a new job. And I found that to be true, until a few years ago. I had decided to leave a wonderful job I had been doing for a long time because I desired a sabbatical and wanted to explore freelancing. After a year of the freelance life, I decided that it was not for me and went back on the job market. What I learned during this process was that getting a full-time middle-management job while unemployed proved to be rather unpleasant.

I was on the market for fourteen months. It was during this period that I really looked to my circles for support. Several times a month, I checked in with my core ring of friends about my goals and strategy as I applied to new positions, trying my best to keep hope alive and stay on course. These people were amazing at providing high-level (and often gut-level) perspective and reminding me of my professional and creative aspirations.

Less often, I would check in with my middle circle about the specifics of a certain position or to get advice on shaping a résumé or cover letter. I would ask about how certain positions might be situated in their fields or institutions, or go over tools for prepping myself for an interview.

I have a Pisces moon and a Libra rising and it is way too easy for me to argue all sides of a case and unearth the benefit in every position, and thus making decisions about jobs can feel epic. Having these circles of influence has transformed my life, and I am tremendously grateful for everyone who has ever allowed me to call upon them for advice. It's hard to imagine how I would have ended up at the great job I have now without them. I can only hope that members of all of my circles feel that I am helpful to them as well—beyond formatting their résumés.

Seeking career advice from prominent people

WE ALL HAVE THAT DREAM **of connecting to someone we admire. Their work and achievements inspire us; they move and shake in circles we'd like to be a part of. Because of their experiences and success stories, they seem to have a wealth of knowledge that we could all learn from.**

Oftentimes, these are pretty prominent people—VIPs—who have crazy busy schedules and who are in the public eye. These are people who are also usually bombarded with questions about advice and mentorship. Even if we were able to make that magical connection (via email or in person), that person may not have the time to respond to said email or take on an apprentice (they may have several mentees already). But that doesn't mean you can't indirectly make them a part of your tribe and learn from them.

Over the years, I've learned that most of those "unreachable" people have generously shared a lot of information about their paths. They have written books and done tons of interviews and talks; it's our job to take the time to sift through that wealth of information to get the guidance we need. The great thing is that it's all out there, and usually, it's free (ahem, visit a library, please).

It may not be a personal connection, but if inspiration and some general guidance is all you need, it's a really great place to start. Here are three ways to go about getting that advice from a prominent person.

RESEARCH

As I mentioned, most VIPs have already shared a lot about their lives, their triumphs and tribulations. You just have to do a Google search or two to find what you're looking for. Go on YouTube and watch interviews or documentaries about that person. Search for talks or podcasts they've done. (One of my favorite things to do is to sit and listen to a video or podcast featuring inspiring people while I'm drawing.) Read articles, books, or blog posts by or about that person. You'd be surprised by how much you can learn. Be sure to take notes as you listen or read.

EXPERIMENT

I'm a firm believer that every path is different. We each have our own journeys and experiences. But sometimes, figuring out where to go next takes a little bit of trial and error. So after you've gathered some ideas or inspiring advice that really spoke to you, go try it out. Using that person's path as an example, try some things that they recommended, or even try something that worked for them. It may or may not work for you, but even if it doesn't, what we end up learning can take us to the next level.

CONTACT

If you are lucky enough to have a direct contact, which isn't too impossible during our digital age, reach out—just reach out with care. Remember, this person is probably really busy, so be mindful of that. Don't be a stalker and send DMs to every single social media platform they use. Don't send a bunch of emails, and don't take it personally if you don't hear back. Keep your message brief and to the point. Don't share your life story or ask open-ended questions like "Can you tell me about your life?" (No, go read their book.) Consider asking how you can help them. Think about how they can benefit from being connected to you.

Sola Biu

is a former recruiter and creative strategist at Airbnb who mentors and speaks about building a community that supports one's professional growth. She gives us a few bits of advice on how to utilize our crew as we travel along our career paths.

Understand Your People

Take time to observe and understand the strengths, gifts, and subject matter expertise of each member of your circle. This helps you identify the right person to approach when you need specific advice, critique, resources, and so on. It can be counterproductive to ask the wrong person for advice, so avoid that trap. Understanding your crew also helps you identify unexpected opportunities that are well suited for them that might emerge along your journey.

Credit Your People

If people have helped you along the way, acknowledge that support. This is so important. Sometimes people feel the need to support the myth that success is a solo effort for them (when it isn't) because they feel it reinforces their talent to an external audience. Make it a point to continually thank the team of people who helped you arrive at your destination. When celebrating milestones, my friends and I always say, "When one of us rises, we all rise," and we genuinely mean it.

Ask for a Critique

It's easy to use your friends to reinforce your good ideas. As vulnerable as it can be, it's also important to rely on them for feedback regarding gaps or opportunities to improve your work. Your tribe is your creative safe space—they believe in you and want you to succeed. They also aren't as close to your work as you are, so they can be more objective when you need that outside perspective. Their feedback can make your work more well-rounded.

Make a Point to Give and Take

Be conscious of proactively offering your time and resources when your community needs support. Don't make it a one-way street.

Leave the Door Open for Others

As you progress through your career, you'll hit milestones that open up new opportunities for you. Be conscious about leaving the door open for others when those opportunities emerge—this isn't limited to your clique, but you should definitely include them when it makes sense. A quote from Michelle Obama on this subject: "When you've walked through the doorway of opportunity, you do not slam it shut behind you. You reach back and give other folks the same chances that helped you succeed."

Maintain Creative Health

Remember to nourish yourself and your professional community. It can be easy to unintentionally fall into a pattern of only giving each other professional support. This can be draining over time. Cultivate moments of discourse and fun that have no professional agenda, when possible.

Celebrate the Effort as Well as the Result

Define success clearly for yourself and make sure it includes the behind-the-scenes efforts of all those involved. The time invested in a labor of love matters, so be sure to acknowledge this, not just the public outcome, especially with the community that helped bring it into fruition.

Curate a Diverse Crew

Diversity of age, skills, interests, and backgrounds are an asset to your creative community. I once read an article that described creativity as the tension between two opposing ideas. If that definition holds weight, it is important to surround yourself with creative partners who can challenge, extend, and push your point of view far beyond your expectations. Don't exist in a vacuum. Your tribe may have shared values, but your perspectives, skills, and experiences should vary. We are in an era of blurred boundaries. Some of the most interesting and provocative art and creative pursuits right now are cross-disciplinary. I imagine this begins with curiosity about things outside of your world. For example, my creative circle ranges from engineers and designers to former ballet dancers, policy experts, and bartenders. When you examine my projects, you can see all of their influences in my work.

When one of us rises,

We All Rise.

-Sola Biu

HADIYA WILLIAMS

is a talented designer and art director who is often called upon by her diverse group of friends to do design work. She gives us some DOs and DON'Ts for doing business with friends and family.

Consider the relationship.

Know who you are working with. If you are aware of certain patterns within yourself or your friends that might cause tension, use that info to decide how best to move forward. Sometimes when we know people on a personal level, we cross boundaries or take liberties that we wouldn't otherwise. Watch out for this.

Clarify the scope of work.

It helps to determine the business arrangement and scope of work up front, so that there isn't any confusion down the line. We don't want any friendships ending over miscommunication, resentment, or assumptions.

Go into a project with your whole heart.

This is especially true when doing work for people you love. As a creative person, your work is a direct exchange of energy, so make sure it is done with some TLC.

Work for your friends because you want to—not out of a sense of obligation.

Most people prefer an honest no to a resentful yes. Remembering this will save you a headache and a friend.

Rely on your friends and family to sustain your business.

If your friends come to you for your skills, great. Please don't take it personally if they don't. It is nice to have folks who are just friends.

Expect your friends to understand what goes into your craft.

We love our circle and they love us, but that does not mean that they should understand the full value of what we do. In the past, I used to undervalue my work so I did not "burden" my friends with the truth. In the end, it ended up being harmful to me because I was assuming that they would just know. If you decide to charge for the work that you do for friends, be honest about the value of the work.

MEDIA AND TECH ENTREPRENEUR

Lisa Nicole Bell

Shares how she cultivated her professional tribe

Lisa Nicole Bell

With your career path in media and tech as a writer, director, and producer, your work overlaps multiple disciplines and industries. How has your professional network helped you navigate those different worlds?

My network has supported me in a variety of ways. Sometimes it means encouraging me to simply keep going and working in the direction of my vision. Other times it means they help with introductions, referrals, and tangible support. Because I work in different verticals, I have the pleasure of working with an array of smart and interesting people. By having access to them, I've been able to expand my understanding of what's possible and be more creative in my work.

Were you intentional with how you built your professional network? If so, how did you build that network?

I was very intentional with how I built my professional network. Because we're all so busy, we all need to have some semblance of a strategy if we want to create meaningful connections that are fruitful. I built my network on a few core principles: authenticity, curiosity, and generosity. I don't believe in using people for my benefit. I prefer to create mutually beneficial alliances with people I genuinely like and trust. Granted, we can't always work with our favorites, but I try to avoid doing things with or for people solely because it will benefit me now or in the future.

I'm a curious person by nature, so it's not difficult for me to be interested in people, but this helps dramatically. Most people think they have to be interesting in order to magnetize a network, but the truth is that it's better to be curious and interested in other people. The more you understand what drives someone and how they think, the more effective you can be as an ally in their network. I always ask people how I can help them and strive to be generous in how I do business. Thus far, this strategy has proven to be very effective. When people think of me, they may think of my accomplishments or smarts, but they also see me as someone who is helpful, which for me is important. By helping other people get what they want, I've been able to get what I've needed in many ways.

Do you have a mentor as a part of your community? If so, how do you utilize that relationship?

I don't have an individual that I've labeled as a mentor, but there are many people I consider mentors in various capacities. For me, it's about asking what I can learn from a person and identifying strengths they may have that can inform or elevate how I'm approaching my work. Sometimes I may reach out with a question or request, but in many cases, the connection alone is helpful.

Do you have any advice for supporting one's friends professionally?

Supporting your people is a mind-set. By that, I mean that you have to reframe your thinking to be one of openness, generosity, and collaboration. When you find yourself naturally thinking that way, it's easier to find ways to support your tribe. Of course, I'm also a fan of just directly asking people how I can support them. But it's also nice to occasionally anticipate needs or be an asset because you're always thinking about opportunities to expand and edify your creative community.

3

Being SOCIAL & HAVING FUN

*I'm an introvert

People never believe me when I say I'm an introvert.

But I really am. The perfect day for me involves staying in writing or drawing while drinking tea or listening to some music. I've learned over the years that I need that me time to reflect, rejuvenate, and connect with myself.

What I can't deny, though, is how important it is to also make time to get out and have fun—despite how much I might enjoy having quiet time at home or in the studio. Doing things with friends, such as grabbing drinks, escaping on a day trip to the beach in the summer, or strolling through an outdoor market while downing some ice cream are great ways to disconnect from work. There's always work to do, projects to pursue, and more to create, so sometimes we actually have to force ourselves to have fun. Hanging out with friends is refreshing; it takes us out of our heads. It also offers a different perspective on life, especially when we partake in activities in which we have no idea what to expect. And sometimes it's a good idea go out alone to make new friends.

A few years ago, I attended a pop-up vintage event in D.C. on a lazy summer afternoon. I really wanted to stay home, but having just returned to the area after living away for years, I thought it would be great to just get out and see what I might find. The event was well attended with stylish folks and artists. That afternoon, I met four amazing people. We had such a great conversation and connected with our interests in art, design, and fashion. Today, I'm still cool with all of them, and one in particular has become a dear friend. I really would have missed out on the opportunity to make longtime friends if I obeyed my initial impulse not to attend that funky, intimate event.

So I encourage you to get out and have fun. Take a break, try something new, and give yourself permission to laugh and be silly. Make time for friends and make time to meet new people to help expand your circle. Both your creative practice and your social self will thank you.

IDEAS FOR HAVING FUN

WINE TASTING

GO TO A CONCERT

INVITE 10 PEOPLE to BRUNCH

TAKE a DAY TRIP OUT of TOWN

Prepare dinner with friends

GO DANCING

join a team sport

CELEBRATE A UNIQUE HOLIDAY

ROLLER-SKATE

Jessica Caldwell

Jessica Caldwell, an interior designer, artist, and member of my creative family, reflects on how a visit with friends in Sweden gave her a new creative perspective.

DESIGN IN ALL its forms is a "create on demand" job. While I love to say that creativity is limitless, in this career, there are days when the flow of on-demand creativity feels blocked. When I feel this way, I know it's time to call on my people.

After a relocation and a new job, my most recent bout of creative burnout left me in dire need of an adventure. Luckily, two of my expat friends, who were living abroad in Sweden, convinced me to pay them a visit. Numerous emails, several WhatsApp conversations, and one lost passport later, I landed in a new country. I was unsure of what to expect but knew that a week with my girls would have me surrounded with love and lots of laughter.

In Stockholm, I enjoyed long walks, *fika* (a Swedish coffee ritual), amazing dinners, and tons of design inspiration. During my stay, I hopped on a train to Mariestad, a quaint historic harbor town a few hours outside of Stockholm. I admired the beautiful architecture, ate at some amazing outdoor pop-ups, and laughed with my friend into the wee hours over a bottle of wine and Chinese food. During my visit, I had an opportunity to refresh and rejuvenate.

With my girls, each living in different Swedish cities, I found myself exploring a country I had never dreamed of visiting. My Swedish adventure led me to vast moments of inspiration (once my intercontinental jet lag subsided). Some of the inspiration was for work, but mostly, it inspired the way I hope to live. I found myself prioritizing fun throughout my day. Dancing with friends inspired me to listen to music during my workday. Memories of chats during those long walks in quaint Swedish neighborhoods inspired me to slow down and absorb all of the goodness surrounding me.

After my experience in Sweden, I realized that when I'm too connected to my work, that is the exact moment when a creative block develops. This reminds me that it's time to get out and enjoy life.

My creative family, which consists of the most joy-inspiring, talented men and women, reminds me to laugh, to be silly, and not to let life slip away from me. With them, I have danced, sung, and vacationed my way through the toughest of creative blocks, hardships, and even some heartbreaks. Most importantly, they remind me of the value of play and how it is key to being open to creativity.

Today, my crew is spread across the world. And even though I can't always immediately hang out with them, I still feel very connected to them. A crazy text can enliven a workday, and making plans to meet with friends on vacation gives me something to look forward to when I'm just trying to get through a tough day, week, or month.

My creative tribe is my ultimate inspiration. They are creative not because they are artists, but because of the way they approach life, with light, enthusiasm, and vigor. One night of dancing or one great trip away with them, and I'm ready to knock down every creative block before me.

Justin Shiels

is a graphic designer and connector who knows how to work the room in both social and professional settings. He gives us a few of his DOs and DON'Ts on making new connections while navigating these often intimidating atmospheres, recognizing that fun and networking can in fact go hand in hand.

Invite a friend who enjoys talking to strangers.

If you're shy about approaching new people, allow your extroverted friend to be your tour guide.

Wear something you feel confident in.

When I'm dressed to impress, I stand up taller and feel ready to meet new people. One additional idea is to wear a conversation starter. This can be a tie with an eye-catching pattern, a funky sweater, or a unique brooch. This gives other guests a direct way to connect with you.

Give every person your full attention while you're talking.

One trick is to angle your body directly toward the person to ensure that you're fully engaged.

Follow up after meeting someone who you think is interesting.

Sending a short email a few days later will help you stay on his or her radar for the future.

Throw your own events.

The easiest way to do this is to find three to five people you think are interesting and invite them to grab a drink. Now you've facilitated an impromptu meetup that benefits everyone.

Monopolize too much of any single person's time.

My general rule is to get in and speak for about seven minutes. Then excuse yourself to grab a drink or use the restroom.

Take yourself too seriously.

Don't be overly professional when trying to make an authentic connection. Networking is about showing the world who you truly are.

Ask someone what they do.

Instead ask, "What are you interested in right now?" This question encourages a more thoughtful conversation.

Be the last person to leave the party.

My personal philosophy is to leave right after the party is the most crowded. My best advice is to leave when your energy level is still high.

Think you have to connect with everyone.

I bring seven business cards to functions and set the goal of making seven connections at an event. Once I've passed them out, I can head home.

My creative TRIBE IS

my ultimate inspiration.

*Jessica Caldwell

MAVIS GRAGG

When I met Mavis Gragg at a mutual friend's cocktail party a few years ago, I was instantly drawn to her friendly smile and warm spirit. She has a way of making genuine connections and bringing cool people together for her social gatherings. I was curious to know how she does it, so here she shares about how she uses her tribe to create successful social events.

My day job is dealing with death and dirt. What does that mean? I am a lawyer and I help my clients create security, legacies, and intergenerational wealth with legal strategies. Outside of work, I am also an epicurean and art enthusiast with a penchant for traveling. And I love to share my curiosities with my community by hosting social gatherings.

Over the years, I have hosted many events. It's usually just me wanting to expose others and myself to a topic of interest or to support someone I care about. For example, more than ten years ago I started hosting informal wine tastings with my friends so we could learn more about wine. We're still meeting today. Since then, I've hosted book releases, fundraisers, community talks, art trips, dance parties, and a coloring and cocktail party celebrating the author of this book that you are holding in your hands. Regardless of the type of gathering, my creative squad is essential to the success of my events. My crew plays an integral role in my event planning. Here are some tips on how to think of your crew as key players in making your next social gathering successful.

Thought Partner

A thought partner is someone who you can bring an idea to, regardless of how out of the box it is. They must be a good listener with great brainstorming skills. They also challenge you to be even more innovative and help you maneuver through the planning process.

Cheerleaders, aka
Ride or Die Chicks/Dudes

You can't have too many of these on your team. These folks will support you at any event. Whether it's an artist's talk, wine tasting, natural hair forum, coloring book party, academic book release, or law-related community dialogue, my cheerleaders attend and promote every single one. This means a lot because I know at least a few people will always attend an event, but also because it affirms my creativity in a very meaningful way.

Inspirator

I invented this word to refer to someone who is a role model—someone who embodies the kind of experience that you want to create with your social event ventures. They are exemplary of what creative visioning is to you, and their own event-planning achievements are inspiring and admirable.

Accountability Chief

This role sounds heavy, but it's pretty easy. Their job is to check in with you to make sure you haven't given up on your plan. My accountability chief lives in another state so she cannot attend most of my social events. However, she always checks in to make sure I'm still pursuing them. She also wears the cheerleading hat with respect to reaffirming that I'm doing something worthwhile.

A Word about Naysayers and Trend Followers

People who can't envision the extraordinary or who rely on what's trending to determine if they will support an event are people you do not want on your team. You likely have friends who are naysayers or trend followers. They may even be good friends, but your friendship is not based on them being a part of your creative network. Although they are not on your team, they shouldn't be overlooked because these are the folks who can derail your creative thinking and sidetrack you. So be mindful of them and remember who your creative tribe really is.

VACATION ALONE

Say yes to invitations

Meet new people, expand your tribe

IT HAS ALWAYS been a dream of mine to speak better Portuguese. Although my mother is Brazilian, she didn't speak enough Portuguese to me as a child for me to grasp the language enough to speak fluently. So after promising myself I would learn it for a long time, I finally signed up for a Portuguese class. This once-a-week early Saturday morning class was a lot of work, but it was also rewarding. I did get a better handle on Portuguese, but what I didn't expect was to walk away with lifelong friends.

When I met Elsa, Betsy, and Javiera, they had recently returned from a trip to Brazil. They fell in love with the country, culture, and language, so they signed up for the class. On the first day, we connected because of our commitment to learn the language and our shared dream of maybe living in Brazil one day.

After class we would get brunch or ice cream with the intent of practicing our Portuguese, which we rarely did. We just chatted in English about our week or the news. Soon, we were getting together regularly, and then we became a part of each other's monumental life moments, like birthdays, engagements, and big moves to new countries. Years later, we each live in different parts of the world (Sweden, Chile, the United States, and Australia) but are still very much a part of each other's lives. We have a group just for us on WhatsApp where we stay in touch, offer encouragement, and share photos and updates. These ladies have become essential to my life. Who knew that taking a Portuguese class would expand my tribe in such a phenomenal way?

take a class

GO TO AN ART MARKET

JOIN A PROFESSIONAL ORGANIZATION

GO SOMEWHERE **NEW**

start a neighborhood project

VOLUNTEER

GET INVOLVED IN YOUR COMMUNITY

JOIN A MEETUP GROUP

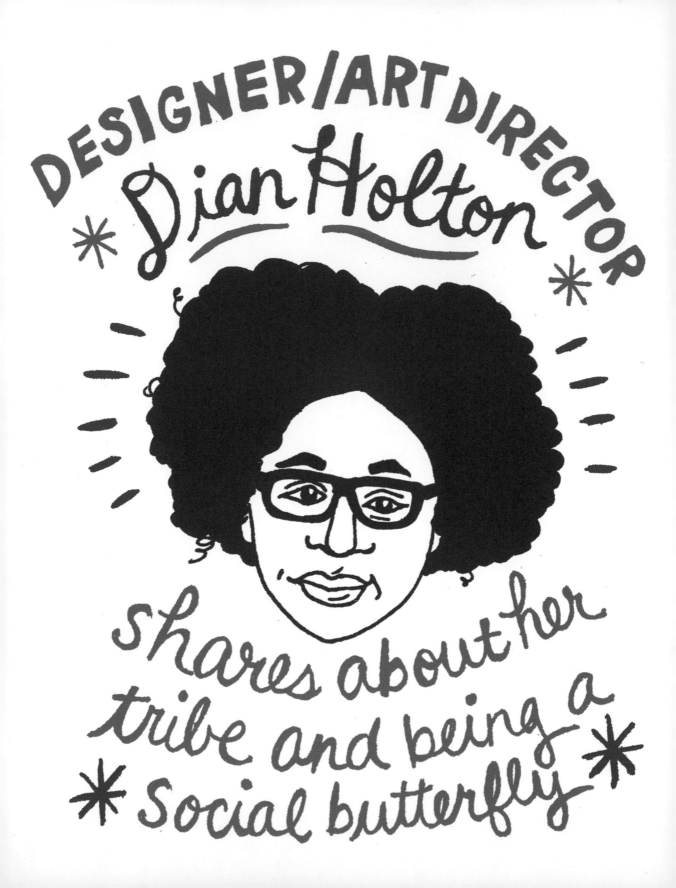

Dian Holton

~~~~~~~~~~~~~~~~~~~~~~~~~~~~~~~~~~~~~~~~~~~~~~~~~~~~~~~

**Tell me a bit about your creative tribe. How did you meet everyone? Are they diverse in terms of disciplines? How do they support you? How do you support them?**

My creative tribe is dope. They are a cornucopia of ladies of color who have careers in creative fields and leadership positions. They are smart, beautiful, fly, open-minded. They love to travel, are opinionated, are vocal, have various musical interests, are tatted, and aren't afraid to eat.

I met four out of five via my job as an AARP art director and the fifth when working as an art director at *USA Today/USA Weekend*. We support each other by being available to talk about work conflicts, ethics or morality issues, and the conceptualizing of projects. We refer each other to jobs, serve as job references, suggest each other for talks, and show up to support each other when one has landed a speaking engagement or any other amazing opportunity. I meet with them routinely to discuss all of those things and other topics that need face time beyond a phone screen or monitor.

Most importantly, we make sure to let each other know that we are there when times get rough. Sometimes it takes a friend to candidly tell you, "Hey, stop, take a break," or "You're doing the most, slow down. Let's go get a massage." My crew is not afraid

to be unabashedly unapologetic in giving props when you've done amazing work or achieved a goal. We brag to each other without feeling or appearing arrogant. Our conversations are easy, and we feel very comfortable together in all settings.

## Is this something you learned over time or does it come naturally?

I think it's a little bit of both. My parents always held positions that required commanding, leading, or overseeing large teams growing up, which meant that they gave a number of speeches. My dad was an army battalion commander and my mom dabbled in everything from store manager and teacher to caseworker. Perhaps through osmosis, I learned how to be comfortable. I've also had eighteen-plus years working in retail as a sales associate, visual display associate, and stylist, so that inadvertently allowed me to be comfortable in various environments. The past decade, I've been very involved with AIGA, the professional association of design, at the local and national level. I've produced a variety of events (large and small) and had the opportunity to be in the same room as well as have candid chats with design heroes and icons. Once I realized that they put their pants on one leg at a time like me, I was no longer afraid or anxious about talking to them or working alongside them. I just really enjoy talking with people, which makes it really easy for me to connect with others.

At events and gatherings, I'm always aware of those around me. I'm looking at who is in the room or space, who makes up that room (the demographics), and how I'm portraying or projecting myself and voice within that room or space. And by space, I'm also referring to social media space. I, like others, am always growing, so I make a point to research and study other people and voices.

## What are some things you do for fun, and how do you incorporate your creative tribe?

I love to shop, travel, take a screen printing or letterpress class, or go to the theater. I also enjoy art directing and styling shoots. As for incorporating my tribe, I try to involve them in all of these things though occasionally I need some time to myself.

One of my most memorable moments was a time four of us celebrated my birthday in Thailand. I've learned over time that you can't travel with just anyone. The friends I often travel with are all very cultured. They speak multiple languages, have an affinity for seeing new things, trying new foods, and meeting new people. This makes for a good traveling crew.

When it comes to taking classes, I like including my people in these projects because I know we will experience something interesting together that might spark a future idea for collaboration. Or if the class yields a solo project, it's nice to have a friend who knows what is involved and can help support you when you want to build upon the idea or take it to the next level. I have two go-to friends who are always down to go to a performance, especially a musical. If I ever want to go to a musical, I know I can count on them both to join me, so they are with me when something cool comes to town.

## How do you meet people?

From the retail spaces I work in to outings in creative spaces (exhibits, galleries, talks, lectures) to friends of friends—meeting people happens everywhere. I've also met numerous people through social media via posts or shared likes.

## Any suggestions for others looking to expand their creative circle?

I'd say get out. Get out of your home and go somewhere that involves other like-minded people. And turn your devices off. Force yourself to engage with humans. Be open and try something new. Sign up for a class, and if you can, go solo. That will force you to meet others and not just the buddy you came with. This could also apply to attending lectures and other events.

# 4

# ACTIVATE YOUR COMMUNITY

# *Create what I want to see

**There is a lot happening in the world. When we** watch the news or read news updates online, we are constantly being shown the struggles and challenges facing our world. It can be overwhelming, but instead of feeling hopeless, it's important for us to feel empowered. We can all do something, big or small, as individuals or as a team. We can create change within our homes, in our communities, and ultimately the world.

You get to define how you get involved, which I talk about in the coming pages. Start with these questions: What do you believe in? What are you passionate about? And how will you use your voice, your art, or your work to change the world?

I am an artist and author who is passionate about creating images that reflect what I want to see. I don't see enough of my community reflected in the media and in art and design. Because of my work, I understand the power of an image, and I strongly believe that when we see reflections of ourselves, our stories and experiences are validated. So the nature of my work has been to make images and tell stories that focus on people who are often

ignored. My art is my tool for activism and my message can be seen in the form of illustration, books, art, and media.

Because of my excitement and passion, my consistency and dedication, my friends see how important this work is to me. Therefore they support my endeavors, they share my messages, and they recommend my work when they come across related opportunities. And I do the same for them. Even if we don't directly get involved with each other's community projects, we are there to nurture each other's missions and goals. We encourage one another. All of which helps us feel empowered. And that alone can help change our world.

# define YOUR activism

Within my group of friends, we all have different issues that we feel strongly about (sometimes they overlap), and we all have different ways of getting involved. Some like to be on the ground and protest, others like to write letters, and there are others who prefer to capture the movement through their art. I have friends who like to serve through volunteer work and others who write about the issues for blogs and publications. All of these are forms of activism, and they are all necessary and important. You and your crew can be active in your community as a unit or as individuals. You get to decide what speaks to you and what is the best platform for your voice.

# JESSICA SOLOMON

Jessica Solomon, a community activist
and changemaker, shares about an
empowering sister circle experience.

**MY PASSION FOR ART** as a tool for social change grew out of a transformative moment with my community. It was a sister circle. You know, the women-only get-togethers full of lively conversations that range from the mundane to the cosmic, from pop culture to policy change. There are usually amazing snacks and wine.

Sister circles have always affirmed my lived experience. There is a sacredness in being seen. In the spring of 2008, I was invited to a black feminist sister circle in honor of Saartjie "Sarah" Baartman. It was the anniversary of her "homecoming." Almost two hundred years after she was taken from South Africa and put on display as a sideshow act across Europe, her remains traveled from the Musée de l'Homme in Paris to her birthplace, where she was finally laid to rest in May of 2002.

At the gathering, we speculated about what her life might have been in those inhumane conditions. We imagined the ways she sought joy in the midst of it all. We talked about intersectionality, power, feminism, agency over our bodies, and a host of other things. Women read poetry in between our tangents. We sang. Some cried. It went late. I was changed.

For the first time, I connected my lived experience to a historical context. I wanted more people to feel what I felt. There was something about the art and cultural expression that evening that I knew was critical in scaling up an experience like this. What could this sister circle be like with an audience to witness it, or as a call to action?

That summer, I put out a call for black women artists to join me in devising art that explored the themes discussed over wine and snacks that magical spring night. I called the experiment the Saartjie Project. Twelve brave women artists answered the call, and I produced what I thought would be a one-night-only kind of deal. When I think about that time, I'm reminded of the following quote from Dr. Clarissa Pinkola Estés's seminal text *Women Who Run with the Wolves*, "And if she cannot find the culture that encourages her, then she usually decides to construct it herself. And that is good, for if she builds it, others who have been looking for a long time will mysteriously arrive one day enthusiastically proclaiming that they have been looking for this all along." The women showed up. The Saartjie Project was so well received that we established an official ensemble and developed a community arts and direct action methodology that would go on to be used in activist circles and schools interested in leveraging the arts for change. We did this soul work together until 2012.

It was during those years that I cut my teeth on what it meant to be a cultural worker—how art was always political. I learned how to articulate the importance of cultural practice and how womanist performance art knowingly and unknowingly shaped me. I am grateful for the sister circle hosts who answered the urge to gather us. I'd need a litany to thank everyone—the many women, mothers, sisters, friends who poured themselves into the work that changed me and many others.

# ways to ACTIVATE your tribe

We all have social causes we feel excited and passionate about, but it can be difficult to convince others to be as passionate or as involved as we are. I truly believe that in addition to gathering volunteers, getting people to spread the word, or soliciting donations, we can inspire others to get involved just by being an example. Here are some tips for getting your crew involved with what you believe in.

# Show your passion

Let your excitement about a cause or organization shine through. Talk about why you're involved and what serving others does for you. Be genuine, and people will be attracted to your enthusiasm and perhaps even inspired to help out.

# Be committed

Show your friends your passion through your commitment. We can invigorate others by simply being consistently involved and engaged with projects for social change.

# Share info

Create a blog, newsletter, or Facebook page to share information about what you're doing and how your work is affecting a community. Of course, you can post or send as often as you like, but also be careful not to bombard people with information. Little bits at a time can be super effective.

# ask for help

And of course, you can directly ask the homies to get involved. If you try the previous suggestions and they see your passion, they will most likely say yes.

# De Nichols

**is a designer with a focus on inspiring entrepreneurship for change. She shares some DOs and DON'Ts on engaging with others in the realm of activism.**

## Do right by people.

This is a cardinal rule I credit for everything that I'm able to do, build, create, and actualize as an activist and designer. Even if you have a track record of great accolades and experience, if you mess up in this work—if you don't do right by people or make up for any mistakes that are sure to happen along the journey—the road might not be long for you. Trust, integrity, transparency, and heart are core to movement building, so be diligent in keeping these in the forefront of each action you take and decision you make.

## Realize that ingenuity lives within intersections.

In my practice with Civic Creatives, my team uses what we call Common Cultural Denominators to bring people together and generate fresh ideas and approaches to the issues that still cycle in our generation and society. We recognize cultural absolutes— like how everyone has to eat, and everyone has a story, and everyone has to use public spaces—and we use food, art, storytelling, and public interventions and disruption to engage. By keeping intersectionality central to our work as a team largely made up of queer women of color, we are able to navigate boldly and fearlessly amongst seemingly disparate communities and help weave, mediate, and connect perspectives.

## Meet people where they are, how they are.

Love and support them as they grow. Grace is necessary for community building and community keeping. We have to recognize and accept that everyone marching and rising up may not be on the same levels of consciousness as we are.

### Let your ego take over.

Keep your ego low and impact high. I learned the "Low ego, high impact" mantra in the midst of the unrest in Ferguson. My friend and fellow activist Kayla Reed would always say it to keep us in check when tempers would flare or personal tensions would rise. For the sake of freedom, we have to keep our pride pointed toward justice and equity—even amongst ourselves. Else, hubris will be our downfall.

### Forget about you.

Be gentle, loving, and easy on yourself, for these are also radical acts.

### Hide your gifts, nor your magic.

Speak up. Show up. Be present, and don't hold back from contributing what only you can give to this world.

"stop waiting for

the world you need."

—COLE & AISHA

Dovecote Café and Brioxy Founders
Cole & Aisha

on empowering their tribes and community

# B. Cole & Aisha Pew

**Both of you have been community activists for some time. What led you in this direction with your work?**

Activism has a very specific image, of a person organizing or protesting. We think of ourselves as community curators who use all the tools available to us. Sometimes that's organizing, but it's also entrepreneurship, art, training, teaching, and partying. We want to be part of a movement of innovators of color who are reclaiming our hoods, creating solutions, and living in spaces of joy. We know that we are the only ones who can deliver that to ourselves and each other.

## Describe your people and how they support you.

Our community is made up of people who think beyond what they've been told. Visionaries and doers. Those who seek different ways of approaching and looking at things through means and methods that include art, technology, urban development, or social change. They think in vibrant colors and are energized by the possibilities of things. They don't take things at face value. They are ready to show up for their people. We support them by giving them space to be seen—and know they are not alone. We hack and build with them, creating a hive mind of people of color building a future together. They support us by sharing their journey with us, supporting our dreams in return, and inspiring us to build the circle even larger.

## Do you intentionally blend activism into your personal relationships?

No, we want to build authentic and transformative relationships with others. If that includes activism, dope! If not, cool. We are committed to meeting others where they are. Activism is usually focused on dissent and protest, which are critical tools. But we believe the greatest form of critique is to create. Stop waiting for the world you need. Set the cornerstone. Others who yearn for that future will find you. Soon you will become a tribe. That is how we get free.

## What are some small things folks can do to invigorate their friends to become more involved?

The more people do, genuinely and authentically, the more involved you will become. We believe that living publicly (your values and your beliefs) and sharing that in the world through your actions is how we drive change. That's why third spaces are so important. They are the places in between home and work where we build community. As people of color we thrive in third spaces. Creating them is activism in itself. It shows that there are other ways to be free. It gives people a model, the insight, the possibility, and permission to live that way for themselves. It showcases what a life lived fully can look like. It is so inspiring. That is what activism is. It's saying, "I'm not going to live the life you've prescribed for me. I will live on my own terms, and most importantly, I will do it so that it serves a higher purpose: the love of my people and their well-being." This moment is ours. We simply have to seize it.

# 5

# Take Care of YOURSELF

# Take Care of EACH OTHER

# ✳ building my support system

**A few years ago, I was invited to an intimate gathering** of ladies to reflect upon the year that was coming to a close and to set intentions for the new year. The purpose was to do so with like-minded ladies who all had really positive energy.

Out of the group of six ladies, I knew two (the host and one other I had just met a few months prior). I am super private and protective of my personal life, so doing something like sharing reflections and intentions with a group of women I didn't know left me anxious. But after some tea and then wine, some snacks, and some laughter, I loosened up—a little. And then it was down to business. The host, my friend, started our conversation by sharing some of the things she desired for the new year. She expressed that she had an advantage in our gathering because she was the only one who knew all of us and considered each of us good friends. She assured us that each person invited was there because of the good energy she knew we would bring to the space.

Before each person got to speak up about their own desires and wishes, my friend went on to say that she'd been working with a life coach. Through that experience she learned about how she was blocking progress and growth in some areas in her life, and working with her life coach had helped make some dynamic changes.

In that moment I remember thinking, "Wow, a life coach? What does that mean? How does that work? And how do I get me one of those?"

The rest of the afternoon was lovely and warm. I left inspired and uplifted. And the words *life coach* kept ringing in my ears. You see, that year was a year of change for me. My job at the time was good but not great. I wasn't happy. And in the midst of that, I had just turned down a six-figure job offer in New York City. The money sounded awesome, but I didn't want to go back to the corporate world. Something in my gut told me I would regret taking that job. But even after I declined, I felt extremely depressed. If the work I was doing wasn't fulfilling and that job in New York wasn't the answer, then what was it that I was supposed to do?

Just before that gathering at my friend's house, I decided I would work on projects, both personal and freelance, that felt good. I committed to the idea of being "an artist" and decided that I would leave my job at some point so I could pursue that "artist" direction full time. But I was afraid and not sure how to go about making that move. So when my friend mentioned a life coach, I thought perhaps that was a step I should take.

So I conjured up the courage to ask my friend about her experience and for a possible referral. Even though she was so open and honest about her journey, I was embarrassed to ask about her life coach in fear of her knowing that something was wrong with my life. Our conversation about it started via text, but we decided to chat on the phone when the messaging got too detailed and deep. Asking her questions and hearing more about her experience solidified how much I wanted to try working with a life coach myself. And so I did.

It was expensive, emotional, and we did a lot of work. This life coach gave me the tools I needed to navigate the next chapter of my life (and the chapters to come). Through that work, I found the courage to leave my full-time gig, so I could focus on pursuing a new direction with my creative passions. And most importantly, she showed me that the answers I was seeking lay within.

My life coach, also a certified therapist, is a part of my network. She is another sounding board, another perspective I can trust. It's a form of self-care that works for me. I understand that kind of guidance isn't for everyone but my wish for you is to find a person, a practice, a community that nurtures who you are and who you are becoming. A place you can go to, whether physical, virtual, or spiritual, that simply allows you to be you.

# Protect YOUR SPIRIT

When thinking about the people you consistently hang around, and even beyond (folks at work, or who you follow online, or what you listen to on the radio), it's important to be mindful of how they can influence how you feel. Protect your spirit by making the following a regular component to your self-care routine.

## Listen to Positive Messages

Pay attention to what you're listening to. I had an experience where I was listening to an audiobook about someone's personal experiences, and it didn't make me feel good. I was looking to be encouraged and instead I would feel anxious. So I stopped. Whether it's a podcast, songs, or an audiobook, be aware of how the messages are making you feel. If they are bringing you down, then stop immediately.

## Turn Off the News

It's great to be in the know about what's happening around the world. Oftentimes, though, we get stuck in the news loop where sensationalized reports are being played over and over—promoting fear and negativity. Be aware of how much you're watching and also consider other news sources, like visiting a reputable online source or having news updates sent to your email address. You can be updated with current events without being bombarded.

## Hang with People Who Wish You Well

Make sure the people in your crew have your best interests at heart. You know who they are; you can always feel the folks who genuinely support you and the others who make you feel inadequate. Listen to your gut when you're hanging out and make a conscious decision about who you want to spend your time with.

## Avoid Sponges

Stay away from energy zappers, those people who pull everything they can out of you but are never there to reciprocate.

## Share Your Dreams with People You Trust

Be mindful about who you share intimate details about your life with. You want positive energy going to your dreams, challenges, and concerns. The people you trust will provide that, so go to them for support.

## Stop Following

In some cases, the people we follow online can be an extension of our creative community. Pay attention to who you follow. Are their posts uplifting and encouraging, or is this someone who's always a Debbie Downer? Do you follow someone who seems super judgmental? Maybe someone projects perfection, and it doesn't gel with you. You get to curate who you follow, and ultimately your feed should reflect how you want to feel. So examine how you feel following this person, group, or brand, and unfollow where needed.

# SAY NO

# ING

One of the biggest lessons I've learned over the years is being comfortable enough to say no—and this is across personal and professional relationships. It's so easy to feel like we should do something. Meanwhile, we ignore that gut feeling telling us we don't have enough time, our heart isn't in it, or we're just not that interested. Giving ourselves permission to say no opens up space for the awesome yesses coming our way. It also makes us better friends, partners, and colleagues when we focus our energy on doing what really speaks to who we are.

hey girl,
How are

you?

# creative lady CHECK-INS

It's so easy to get caught up in our own thing that we forget that others might need a boost or just a hello. I love doing creative lady check-ins to see how my fellow artists and designers are doing. Whether it is a quick DM, text, or email, it's a way to stay connected and in the know even during a super-busy schedule.

# e BOND

**is an artist who incorporates her love for nature into her work and self-care rituals. She gives us some tips on how we can use the outdoors to reconnect, relax, and rejuvenate and how nature can be a part of our creative community.**

### Walk It Out

As a lifelong introvert who also happens to love a good conversation, I noticed early on that it was often easier to have deeper, more meaningful conversations with people when we weren't just sitting idly face to face. I learned that conversations evolve more organically when the body is actively engaged in something else: chopping vegetables, planting new bulbs in dirt, sewing in a group, walking side by side together. The pressure eases and thoughts flow naturally. I recommend taking a nice long walk for no other reason than to foster a good conversation with a loved one. It is the perfect conversation catalyst, and it is free therapy.

## Let the World Amaze You

Amazing. This is a word used so freely in our common lexicon that it ceases to evoke the splendor and gravity of its true meaning. To be amazed is to be astonished. To be stopped in one's tracks. To have one's breath literally taken away. It is not a mundane occurrence by any means, but it can be a frequent one. And as singular and unique an experience as this may sound, amazement can be just around your corner. Stare at the sky and ask how it manages to hold up those rain clouds, or better yet, all those stars. Embrace how trees can always find the exact direct route to sunlight or every bird always knows exactly where they are going— they never seem confused. Just stand there and count all the things in your line of sight that are truly awe-inspiring.

## Breathe

This is important, so I am going to put it right here in the middle of the list. If you forget everything else, do this at least once a day. Find a beautiful, quiet (if possible) space, sit down, and breathe in and out ten times. Then sit there and be thankful you can do that.

## Get Curious Together

It only takes one question and one friend to start an adventure. Find the one person in your crew who is always looking, seeking, asking "What if?" or "I wonder why?" Get that person in a car or on a long walk and just start asking some questions. It really doesn't matter what the question is, as long as you have one to start with and a friend who is up for the challenge.

## Get Distracted to Pay Attention

One thing I notice as I walk trails in national parks, especially in the iconic parks like Yosemite or Joshua Tree, is that people tend to forget that they are actually in a park. They forget to remember where they are, even when they have just arrived. Somehow it feels like they are still on a Manhattan sidewalk at rush hour. The tendency to rush through even the good moments we have planned for takes over, and every experience becomes checking another to-do off the eternal bucket list. Go see a redwood tree, check. Walk the Appalachian Trail, check. Look, I know it's so hard to switch gears, but in our hard-earned

free moments, we have to remember we are where we wanted to be. We made it. So take a seat, a few breaths, and commit to being there.

**P.S.** If you ever need any help with this one, find the nearest kid. Watch how they wander from tree to tree or zigzag under a branch or climb over a pile of rough rocks. Notice how their path is never the most efficient—it's rarely a straight line. It will take them longer because they are following one curious thought to the next. Kids are distracted by that crazy-fast butterfly that just flew out of reach, or by the banana slug moving sooooo slowly you can't help but stop to see if it is making any progress. Stopping at each and every stick that might double for a bow and arrow, or magic wand, they fall behind. They get distracted because they are paying such close attention. In the best possible way, they are showing up and committing to the moment, so follow their lead.

## Sharing and Documenting

I love to collect and document everything— everything. So I understand the urgent need to capture a moment. And it's so great to want to share an experience with people who aren't there, but think about ways to fulfill these needs without taking away from the experience you are having presently. The important word here is *present*. Be here, or there, or wherever you are, exactly in that moment. Let the other stuff shift slightly out of focus.

One way I learned to stay present was by leaving my camera at home, which was painful for me at first. But it taught me to think of other ways to record things with my mind, and eventually it started to hone my other senses. I still love to bring a pocket sketchbook to jot down quick words, line drawings, or plant diagrams to jump-start my memory. Fold up a paper map in your back pocket to make notes along the way and just go. Try lo-fi hiking

and lo-fi documenting from time to time, opting to share your thoughts later.

## Take Care

You don't have to climb the highest summit to become more active in nature or to appreciate the land you are standing on. Whatever your current relationship is to this earth, it is holding you, sustaining you, keeping you safe in ways we rarely acknowledge daily. You don't have to make grand steps to move closer to nature, because luckily nature always surrounds you. Just start where you are. Decide to be a tourist on your block, in your neighborhood, town, or state. Choose to see everything with new eyes. Find a few things you want to investigate and a friend who doesn't mind getting lost. Plan a little but leave a lot open to chance. Take your time.

your support system

We need to feel emotionally supported in our network. Here is a list of types of people to identify within your crew and how to best utilize their energy in your time of need. Also consider how you would define your own role within your support system.

# OBSERVER

This is the friend who is always paying attention to what's going on around them. The observer is a great friend to talk to if you're unable to clearly see what's really happening.

# DREAMER

Have a crazy idea or dream you'd like to pursue? This friend will be the cheerleader who will dream along with you and tell you anything is possible. They're great for motivation.

# ADVOCATE

Sometimes it's hard to promote ourselves or speak about how amazing we are. This member of your squad will do it for you without a question: They believe in you and want to see you shine. They make great dates for parties and networking events.

# optimist

When you can't quite see how to get out of a sticky situation, the optimist will help give you a positive perspective. Go to them when you need a pick-me-up.

# Realist

We can dream and think positive, but we also need to be honest and real. Our friend the realist will give us that hard-to-swallow truth. It's hard to hear, but because we trust this person we know it's coming from a place of love. We can use this perspective as needed.

# listener

There are times when we just need to vent. You're not looking for solutions or positive thinking, you just need to get something off your chest—you just want to be heard. This friend will do just that while also validating your feelings.

# Danielle Finney

Photographer Danielle Finney opens up about navigating a mental illness diagnosis and how her community supports her through her struggles.

**SHARING THE STRUGGLE** with mental illness is hard. Really hard. But how else will your friends be able to provide you with the support you need?

Navigating recent life crises and my bipolar II diagnosis, I can attest to just how important it is not only to have a tribe, but to make use of it. After opening up about my mental health diagnosis, I was touched by how many people swooped in to offer assistance where they could, give words of encouragement, be a kind listening ear, and reassure me of my value. The support I received was the life raft I needed at just the right time. And that support continues to this day.

Depression is so insidious. It leaves you feeling like you're not worth it, like no one cares. So why should you? Often it takes a long time to even get to the point of seeking help, let alone being open about it, so to share what I was going through and be met with the waiting arms of supportive friends and family meant the world to me.

Living with mental illness adds a layer of difficulty to life. Just trying to do simple day-to-day activities can be exhausting, and you can often feel as if you are a burden. But it is so important to be reminded of your worth. Your value. Your importance. That you matter. From reaching out to tell me that I am loved, to listening empathetically and understanding when I am having a bad day, to sharing a meal, taking a walk, creating together—my tribe did just that for me.

Being reassured of your value is an ongoing process, and something that we all need to do for each other. It can be done in a number of ways—listening is always a good place to start. From there, be empathetic to someone's situation and recognize your own strengths so you can know how you can provide assistance. Are you good at providing emotional support? Practical help? Encouraging creative expression? Even if it's just a simple text to check in, when you genuinely care, your support will always be appreciated.

We were not designed to live life on our own, so the importance of making use of your community of friends and family cannot be overstated. Encourage one another, create together, and support one another.

"listening is always a good place to start."

—DANIELLE FINNEY

Founder of Black Girl in Om

*Lauren Ash*

talks about how self-care influences her work and tribe

# Lauren Ash

You have created a platform that offers resources and guidance on healing, wellness, and self-care for black women. Can you share with us what it is that you saw or learned, whether in your community, or in the media, that made you want to create Black Girl in Om?

I saw white. Specifically, white women. This whiteness surrounded me in the yoga studios and wellness spaces where I sought out alternative healing modalities like acupuncture and Reiki. I am grateful for many of the experiences I had in the early days of my yoga practice and intentional wellness journey, with all of the caring teachers and the fellow yoga practitioners who surrounded me. However, because I knew of the enormous value of a deep connection with my black and brown sisters, I considered, again and again, what my experience in these spaces would be like if I were surrounded by other black and brown women. How would that change or affect my own relationship to wellness and my healing journey? And how would greater representation and visibility of black women, in particular, in wellness spaces affect notions and perspectives that black women have about self-care? I started Black Girl in Om to create this space myself and to discover how meaningful it would be for me, and for countless other women.

## How has this platform helped you with your own self-care practice?

Black Girl in Om has encouraged me to further consider this truth: that self-care truly is self-preservation for black women. Some folks carry privileges because of their racial and gender identities, as well as economic backgrounds, that allows self-care to be a hobby or another task to check off the to-do list. But black women are disproportionately faced with mental health challenges, physical (and psychological) dis-ease, and lack the financial means or access to healthy food and health care. Self-care and holistic wellness is not just supportive but, at times, crucial to our survival with what we face. BGIO and the hundreds of women within our community who I have been blessed to meet in person, as well as the tens of thousands of women that I get to interact with in our online community, remind me that self-care is not a trend for us. It's not a checklist activity. Self-care is something to be practiced in whatever way we can as much as we can. Simple actions, from cultivating awareness of our self-talk and affirming ourselves through mantras to monitoring the energy that we expend for other people as compared with the energy that we give our own selves, is self-care. I feel even more conviction to take my own self-care seriously, especially my mental health, because of this truth.

## Tell us about your self-care rituals. How does your creative family fit into your routine? How have they supported you through your journey of being fully you and loving yourself?

Currently, my go-to self-care rituals include making healthy meals for myself, mindful meditation and at-home yoga and stretching, workouts at the gym, and therapy. My creative family fits into my routine because many of them are on a journey toward greater self-love and wellness as well. Simply talking about things like therapy, openly, takes away the stigma. By joining me for kickboxing class, I feel a boost of encouragement to go again because anytime I can double up bonding with a friend and working up a good sweat, I'm there!

**Has working on Black Girl in Om taught you any lessons about building strong relationships that align with your wellness beliefs?**

Absolutely. The first messages that I received from a dear friend and mentor of mine regarding how to do business boiled down to this: approaching everything from an abundance mentality. There is enough space, more than enough resources, and enough "spots" for everyone. Everyone, in my world, includes other black women yoga instructors and black women creative entrepreneurs and visionaries who are carving a path in the wellness world. I try to remain rooted in this. I'm big on collaboration and mutual support and praise. The heart of my work is to affirm the lives of black women, so why wouldn't I want to cultivate and build strong relationships with others doing the work, as well, or send good energy and vibes toward others who are doing it too?

# 6

# Be CULTURE CURIOUS

# ✳ going beyond our circles

## I grew up in a small suburban town just outside of Washington, D.C., and it was everything that comes to mind when one thinks of a stereotypical suburban community. It was quiet, isolated, there was a huge strip-mall scene, and it was not very diverse. I was one of two black kids in my neighborhood.

Fortunately, my mom was someone who loved to be out and about, and being a city girl who had grown up in Rio de Janeiro, she loved to hang out in D.C. And I was there tagging along. We were a part of a vibrant immigrant community, a group of friends and surrogate family members spread across the D.C. area, all looking to belong somewhere far from home. On weekends, we were at each other's houses for dinners, barbecues, and birthday parties. Most of the people were from Brazil, but my mom moved through different groups of folks from many different countries— Kenya, South Africa, Bolivia, and France. Hearing varying accents, eating different kinds of food, and celebrating non-American holidays was a normal Saturday night for me.

But it wasn't just about culture on a macro level. There were friends from privileged and less privileged backgrounds—folks who lived in the city, others from more rural areas. We went to museums and art show openings and farmers' markets in the middle of nowhere. When my parents divorced, my dad moved back to his hometown in Indiana, just outside of Chicago. Spending my summers there as a preteen, I saw different style trends and listened to sounds of

hip-hop that were different from what was being celebrated back at home.

My world was always shifting. Navigating these different groups, cultures, and experiences allowed me to see other perspectives while also refining my own. I learned early on that exposure to another's religion, food, or customs never took away from who I was but simply enriched and informed my own experiences. This affected my life and work in that I always believed I belonged and felt OK in new situations with people who were different from me. The exposure to people and cultures unlike my own gave me the tools to navigate unfamiliar environments, leaving me flexible and able to take risks and explore new opportunities.

In this book, we talk a lot about cultivating a community of people who support us through our creative lives. During these times, when the world feels so divided, I hope that while we acknowledge the importance of keeping like-minded people in our corner, that we also remember to look beyond our immediate circles to make personal, professional, and creative connections.

Talk to people. Don't make assumptions. And engage with others as fellow human beings.

# WAYS to BE (RESPECTFULLY) CULTURALLY CURIOUS

## be open

Try new things, meet people outside of your circle, and do something different.

## DIG DEEPER

Curious about a culture? Go beyond surface level. Learn as much as you can through reading and exploration.

## Be GENUINE

Look at why you're drawn to this culture. Examine your reasons and intentions.

## ask questions

As you're learning, don't be afraid to ask about what you don't know or understand.

## embrace differences

Connect on the similarities but be respectful of others' differing ideas, beliefs, and values.

## don't assume

When connecting with new-to-you people and cultures, always be prepared to learn. Even if you've read every piece of literature, don't walk into situations thinking you know better.

# Maurice Cherry

Entrepreneur and speaker Maurice Cherry gives some insight on how he advocates for inclusion in design in hopes of enhancing the culture of the design industry.

**SOME OF THE BIGGEST** projects of my career have been shaped by a lack of diversity.

It started in 2004. At that time, the Weblog Awards (or the Bloggies, as they were colloquially known) were known as the largest online event of their kind celebrating bloggers from all over the world. I was a pretty active blogger back then, and it struck me as odd that while the Bloggies were a worldwide event, a large majority of the nominees in every category were white. And I do mean every category, including Best African or Middle Eastern Blog.

I was frustrated, but I quickly channeled that into building the Black Weblog Awards, an opportunity for bloggers across the African diaspora to be recognized for blogging, video blogging, and podcasting. The event ran online (and in person) from 2004 to 2016 and has conferred more than two hundred awards to folks like Patrice Grell Yursik (also known as Afrobella), Luvvie Ajayi, Kid Fury and Crissle from the Read, and Baratunde Thurston.

And then there's Revision Path.

I've been working professionally as a web and graphic designer since 2005, and while I knew and interacted with many other black designers throughout my career, we were not being represented in design media or at design events. After years of griping about the lack of visibility to friends and colleagues, I created the Revision Path podcast in 2013 as a platform to showcase black designers from all over the world. And while the focus might seem small, there's still a lot of cultural diversity within what looks like a monolithic group! There's geographic diversity, age diversity, sexual orientation diversity, gender diversity, diversity in career paths, and diversity in the types of design they practice. My goal for Revision Path is that it becomes a resource for the next generation of designers seeking people who look like them in this industry.

Both of these projects illustrate how you can take a lack of diversity and turn it into a positive solution. Look around your community and see where you can use your innate talents and skills to leave your impact on the world.

# Neha Agarwal

is a designer and design educator who loves exploring cultures different from her own. Neha gives us some tips on how to embrace other cultures within our creative communities.

TIPS

**Force yourself to talk with, interact with, be exposed to people and ideas that are different from yours.**

Start with simple acts. Share a meal together. Read the writing of those you didn't grow up reading. Watch movies about unfamiliar people and places. Try foods you've never eaten.

### Exposure to new people and ideas leads to an awareness of our differences.

Awareness leads to understanding. Understanding leads to appreciation, which ultimately grows into respect for, and celebration of, our beautiful differences.

### Embracing and seeking out diverse perspectives is a necessity.

It builds the individual and collective intellect and strength needed to face the many challenges of modern society.

### Each of us has a unique point of view and our own set of biases, or blind spots.

I find when I invite differing viewpoints into my creative circle, we start to fill in each other's blind spots.

### Reaching across differences can be uncomfortable and intimidating.

Do your best to overcome these challenges, but also allow yourself to try, sometimes succeed, and sometimes fail. Maintain the intent and keep taking incremental steps toward closing those gaps.

Being Indian American, I have the best of both worlds ingrained in my self-identity. Sometimes this can be a confusing duality, but mostly, it's a gift that's given me a larger set of tools from which to understand myself, my environment, and the people in it.

"Lean back and don't force it; most solid relationships or tribes are built when there is mutual respect and reciprocity."

— SHELLEY WORRELL

CaribBeing Founder Shelley Worrell talks about her tribe and her cultural identity

# Shelley Worrell

**You are the founder of the platform caribBeing, which celebrates Caribbean culture. Why is it important for you to celebrate Caribbean culture? What inspired caribBeing?**

I get asked this question a lot: Why did we start, what inspired us? I would say that when I conceptualized the term caribBeing as an undergraduate student, there was a huge deficit of Caribbean content and products in New York City, and we wanted to fill that gap to present programming that reflected Caribbean culture and heritage beyond sun, sand, sea, and sexy women in bikinis. The other very important part of our development is that I was a dual major in anthropology with a concentration in Caribbean studies, which led me to travel extensively in the region and to explore the

diaspora. I began to witness the commonalities in food, cultural practices, folklore, and even dialects, despite linguistic and geographic differences. So I would say that it was my travel and studies that initially inspired me to develop a creative hub to produce not only the best but also the most inclusive representations of global Caribbean art, culture, and products that we can. Ambitious as it may sound, this was the vision we initially set out to accomplish when our work began around 2010.

## Is your creative community influenced by your Caribbean background?

My parents, who are both immigrants from Trinidad, settled in Brooklyn when they moved to the United States. Naturally, the neighborhood they chose, Flatbush, was and still largely is West Indian. I also started traveling to the Caribbean when I was six months old and spent most of my childhood summers there. Some of my life's earliest memories are of bathing outside in the rain and taking long hikes to the river with my first tribe: my younger brother, cousins, and lifelong friends from the neighborhood.

As a teenager and young adult, I started participating in Carnival, which is a huge part of Caribbean cultural heritage and identity. It's a tradition that is rooted in music and mas (costume or masquerade) collectives. So I would say my background and lived environments and experiences naturally influenced my creative family, as I have been embedded in this community for my entire life.

## Describe your crew and how they support you.

My crew is inspirational, dynamic, and diverse. For caribBeing specifically, we have a range of creative people and experts in our network, from artists and makers to scholars and museum curators, who we collaborate with on an almost daily basis. There are also a number of people working behind the scenes, like lawyers, developers, and screen printers, who also play a huge role in the growth and development of our brand.

The main way they support us is by engaging in critical dialogue, whether it's about a new production or partnership, assisting with the development of creative materials or products, or telling us what our limits and capabilities are based on our resources. The other thing our group does brilliantly is fill in the gaps, whether that is in an area of expertise or by providing professional services we don't have the capacity to execute.

## Why do you think being exposed to different cultures is important?

As a native New Yorker, I feel privileged to have lived most of my life in one of the greatest cities in the world, a city with virtually every culture represented and where you can travel without leaving the five boroughs. That said, several years ago, I had my most challenging travel experience, which really helped me understand just how important exposure to different cultures is.

I was invited to curate and co-present a Caribbean film program in Poland. I jumped at the opportunity, an all-expenses paid trip to a country where I could discover a new city and culture. When I arrived, I quickly observed that there was almost no diversity, and as a woman of color, people were constantly staring at me and sometimes appearing angry that I was in their country. It was almost as if they thought I was there to steal something from them. Despite this, I persevered and tried to make the best out of the trip, visiting as many cities as I could (I love old European cities), exploring local markets and food, and seeking out people I could connect to during my stay. After two long weeks, I was so ready to come home, but in hindsight I don't have any regrets. I made a couple of wonderful friends who are now part of my network.

One film that made its United States premiere at our annual film program at the Brooklyn Museum last year was narrated by someone from our crew, the young poet and spoken word artist Arielle John, who I met in Brooklyn at one of caribBeing's events and ironically is from the same town in Trinidad (Sangre Grande) as my mother. If that is not a lesson in the benefits of cross-cultural exposure, then I don't know what is!

**For someone who is looking to expand their creative network, do you have any tips or advice on inclusion or how one can gain exposure to diverse cultures?**

My first tip is to lean back and don't force it; most solid relationships or tribes are built when there is mutual respect and reciprocity. To be honest, with my corporate background in global business developments and strategic

partnerships, I didn't get this when we were initially developing caribBeing. We were reaching too much. As soon as I had this realization, magic started to happen. We set the foundation to produce our best work and people, organizations, and institutions soon started inviting us to curate, connect, and collaborate.

The other important thing is to be authentic. It may sound obvious, but it's one of the golden rules in my book. In large part, the strength of our tribe is due to the fact that we have been mission-oriented since day one. Before we put anything out, I always ask myself, "Will this fly with our community? Have we overlooked anything significant that will discredit us? Is this program or product authentically Caribbean?"

In terms of access to diverse cultures, personally, this has always been through travel and exposing myself to international food, art, and design, since those are things that make my heart sing. So I would say, first and foremost, find your interests and pursue them with vigor, even if it's through literature, visiting a local museum or festival, or through digital technologies and social media (you can travel far on the web). And, of course, build travel itineraries and connections around your passions, as those experiences and relationships will be some of the most fulfilling.

# 7

# YOUR VIRTUAL FRIENDS

# *finding my people

**In 2006, I started a blog called Fly with the simple** intention of sharing what I was inspired by, and celebrating the artists of color I wasn't seeing anywhere else. What I didn't expect to happen was that the blogging platform would connect me to like-minded women who had some level of interest in art and design and who were hungry for the same stories and faces I had been looking for online.

Over time, I began meeting some of these readers in person for coffee or at meetups. Later, I would have parties to celebrate blog anniversaries, then a portfolio review for up-and-coming designers, all of which were ways to connect with and celebrate the people who had been supporting my blog for years. Meeting up in person became one of my favorite parts of working on Fly.

So much has happened since then—some career changes, and then some amazing projects like the opening of my Etsy shop to sell artwork and the release of my books *I Love My Hair* and *Becoming Me*. Through workshops, speaking engagements, and book signings, I used these opportunities to meet—in real life—the folks who were sharing my work, buying my books, and being my virtual cheerleaders. All of these people had become a part of my crew in some way.

Which is why I love the possibilities of social media. In high school (before the Internet boom), I had a hard time finding artsy kids like me, who were into what I was into. In college and in my early professional career, I couldn't find other designers and artists of color who had similar interests or who were pursuing similar paths. Blogging and my social media platforms gave me access to a community of people, more specifically women of color, who, like me, were trying to figure it all out in spaces where there were so few of us. This not only helped me find my passion and mission for my work, but also helped me create a network of people who I knew would have my back.

*tell YOUR STORY

**We can say a lot of bad things** about social media: It's distracting, there's too much noise and unuseful information. But what I appreciate so much is that an online platform can give a voice to the voiceless. The space that you create becomes a place where you can tell your story and connect with others who may be going through the same triumphs and challenges. Telling our stories can validate the experiences of others, give folks the permission to tell their own stories, and connect us to people we may ordinarily never meet.

So if you're going through a life change, have a question about a project, or are just looking for suggestions, write about it and post it somewhere. You never know who's paying attention and who will offer that perfect piece of advice or recommendation you may need.

# Jamala Johns

Back in 2009, Jamala Johns started a beautiful blog called Le Coil, which showcased images celebrating women in the natural hair community. Jamala reveals how that online presence allowed her to expand her creative crew.

**IF SOMEONE ASKS** where I first met a certain friend, it's not unlikely that I'll deadpan "the Internet." The friendships and connections that I've made thanks to the social media space mean the world to me. Most notably, it has been very significant in helping me connect with other black female creatives. These women, many of whom live in different cities and even countries, form a community that has been so important in my development as an artist and young black woman. A treasured handful of those friends have become the perfect people to check in with about ideas, current events, and life advice. As a young artsy girl growing up, I never even bothered to dream that I'd be so interconnected with such a vast community.

You probably wouldn't be reading my words if it weren't for these connections. I started following Fly, the blog of our fair author, Andrea, and immediately fell in love with it. A black woman who loved design, textiles, and illustrations as much as I did? How exciting! Over time, as we followed each other's work, she became one of my first online buddies. Our friendship speaks to one of the keys to building an online community: When you enthusiastically engage in the topics and activities that you love online, you'll slowly be exposed to folks who are on the same page with you. Over time, I've curated all my social feeds to surround myself with the people and work that inspire me most.

An equally important component to expanding my online community was sharing my own work and inspiration. One of the central community builders that I've been involved with has been my site Lecoil.com, a natural hair inspiration project. Launched on Tumblr, it was the first of its kind and so I really had to scour the Internet to find the best images. In the process, I began discovering robust microcommunities of people sharing photos of their own hair, as well as editorials and vintage ephemera. I soon began to contribute my own street-style photography of gorgeous subjects around the city. Suddenly, this digital project had an incredible analog component. Since I was spending a lot of time in Brooklyn, I was introducing myself to some of the best and brightest of a globally influential community. I made connections (online and in person) to people who went on to become good friends and collaborators, and I continue to stay in touch with them to this day.

Something I love about these communities is that I never really set out to make friends online. It's all organic—no networking, no schmoozing. Social media simply gives us all a chance to admire each other's work and personalities, helping the right people naturally gravitate toward each other. It's come to the point where I know I'll be able to connect with online friends if I'm in a certain city. London, Chicago, Paris, L.A., Miami, Amsterdam—all places where I knew I could at least stop by for a quick hello to a friend that I'd made in the social media space. I wouldn't be who I am today without the omnipresent and inspiring influence of the people that I've connected with online.

# Maeling Murphy

is known for her blog, Natural Chica, where she shares natural hair tips and tricks in the form of posts and video tutorials. But it's her candid approach that has attracted a loyal fan base to her site and social media platforms. She shares some of her DOs and DON'Ts for making that virtual connection with your audience and online community.

### Be honest and open.

A vital step in finding your people is first making the decision to be honest with yourself and others and being willing to share your personal journey of discovery and growth. We can't expect to support one another or grow together without first being willing to share our struggles and vulnerabilities along with our wins.

### Create the space for engagement.

You can use social media to carve out your own space where your unique voice will be heard. As you stay true to yourself in what you share via your platform, you will find that will start to draw other like-minded individuals into your space. If you feel that there isn't a great deal of discussion online about what you're passionate about, create the forum you desire! The beauty of social media is that there are so many different types of platforms, so whether you're more comfortable with writing, making music, creating art, recording videos, or sharing photos, jump in and let the world know you're here.

### Interact.

Once you start to identify people who resonate with you online, join the conversation! Start interacting with others by sharing your ideas and learning from what they have to share as well. Begin to elevate your interactions beyond the casual likes and retweets by introducing yourself and engaging in conversation.

## Be afraid to ask for help.

If you're looking for support from your network, don't be afraid to put it out there! How can people help if they don't know you need it? At the same time, make sure that you're also offering the same support to others in your circle. As with any thriving relationship, your community should demonstrate a healthy exchange of accountability, support, encouragement, and advice. Remember that everyone is in a constant state of learning, but at the same time, everyone also has something to offer from their life experiences. I believe true growth takes place not only when we receive help but when we willingly assist someone else in their growth as well.

## Just focus on the virtual space.

Once you've identified your fellow travellers online, find opportunities to carry those connections into your offline life. These interactions could be in the form of a phone call, meetups, conferences, retreats, a simple chat at a café—essentially any space where you can form an even deeper connection through meaningful in-person conversations.

use your platform to
help friends shine

One of my favorite things about social media is using my platforms to share the amazing work that's happening within my community. I love using my space to showcase art, projects, and businesses that I believe in, especially if they are from people I know. It's a great way to support their ventures and to help spread the word.

# SARAH WALSH

**is an illustrator and author who has a loyal social media following. She gives some tips on how to make genuine connections in online arts communities.**

## Meet Local Artists . . .

. . . for gatherings where you work on your craft and share your creations on Instagram or the social medium you're most comfortable with. It's great to place names and handles with real people you follow and possibly admire! And who knows, you might make some new friends.

## Support Your Fellow Artists

Buy their art, books, or designs and share them on social media because it feels good to spread the word about each other's work, not because you expect them to do the same.

## Be Authentic

Be yourself and share a little something personal, maybe a struggle or something you find challenging. Don't perpetuate the facade of perfection we all see on social media. First, because it's not reality, and second, it's a lot more fun to just keep it real. Keeping up appearances that aren't truly you is exhausting. Sometimes on Instagram, I'll bring up something I'm struggling with and ask people how they feel about the topic if they have similar struggles. It's so wonderful to hear what other people go through! Just another benefit of being yourself.

## Give Stuff Away!

Giveaways are pretty fun and they're an opportunity to give back to people that are supporting you. If you really want to pack a punch, partner up with other people you follow to give a fun bundle of goodies away.

Don't perpetuate the facade
of perfection we all see
on social media.

Keeping up appearances
that aren't truly you
is exhausting.

-SARAH WALSH

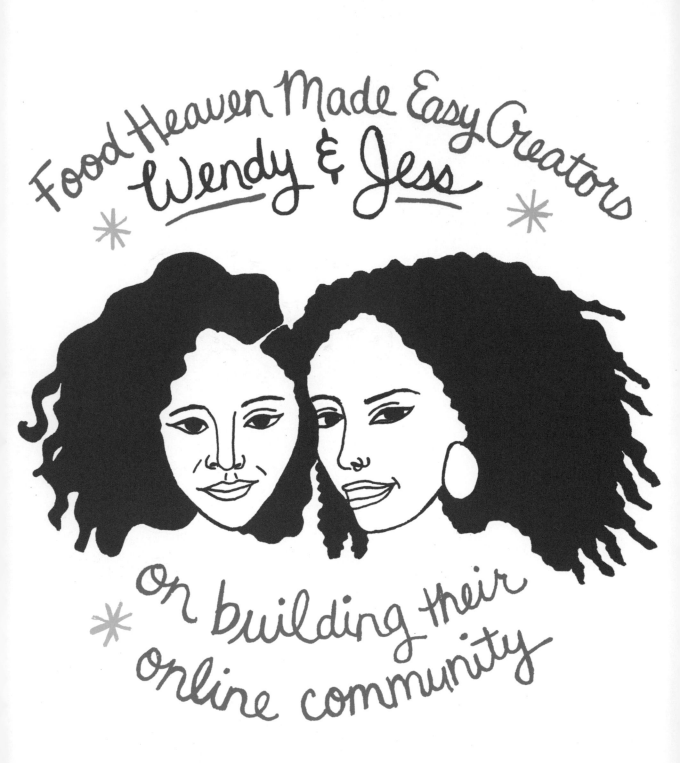
Food Heaven Made Easy Creators Wendy & Jess

*On building their online community*

# Wendy Lopez & Jess Jones

Because of your individual experiences with food and your enthusiasm for plant-based eating, you both created Food Heaven Made Easy as a platform to share what you have learned with others—beyond your work as nutritionists and dietitians. Can you tell us what triggered the need to share your knowledge with a broader community?

**JESS:** Wendy and I worked as nutrition educators who conducted cooking demos and nutrition workshops in low-income communities in Harlem, the Bronx, and Brooklyn. We noticed that we had a great chemistry working together and that many of our participants appreciated being shown exactly how to cook healthy and delicious food using ingredients that were available in their neighborhood. After that job ended, we wanted to reach a bigger audience with our nutrition message by creating a healthy eating and nutrition show on Brooklyn public access television, which later turned into a web series and now a podcast.

Part of what motivates us is wanting to diversify the online nutrition space. While we love our profession, it's no secret that the overwhelming majority of dietitians are white women. There are a lot of women of color who connect with us because we look like them and understand some of their struggles and cultural foodways. People write to us every day saying how much it means to them that we are black dietitians who they can relate to. That's what motivates us to keep going.

**Early on, before having a web series was a thing, you created an online cooking show to inspire others to incorporate more vegetarian dishes into their diets. You were early adapters of using social media and virtual platforms to spread your message, which resulted in growing a loyal community. What three things do you think helped build that community?**

WENDY: 1. Staying true to our purpose. When we first created our web series, our intention was to provide nutrition education that would inspire people to make healthy lifestyle changes. We wanted to use our creativity to engage people and decided that the Internet was a great vehicle to do that. We've always stayed true to our purpose, and I think people can sense that in our work. This has helped to create a trusting and supportive online community that keeps us motivated and excited to create new content.

2. Having a strong support network. We've experienced so many personal and professional challenges throughout the years and having a strong network of friends, family,

and colleagues has been a major catalyst for progress and growth as a brand. We have reached out to people who have more branding experience than us, and they graciously share their words of wisdom. When experiencing major burnout, our close ones helped to ease the load, while also keeping us accountable to our work. We also engage with our online community and ask them what kind of stuff they want us to create. This way we're also in touch with what people actually find useful versus what we think will be helpful for them to know or have.

3. Being consistent. It's so important to practice consistency with whatever work you decide to put out. What I mean is, let's say I decide to create content for my new blog. I am committing to releasing one new post each week. Notice how I just said one new post. You can start small, especially if you have time limitations. If you can dedicate more time and decide to do three posts per week, then honor that and make sure you keep it up. Once you start developing a following, your online community wants to know when they should look out for new material. They don't want you popping up one day with all this new content, and then going MIA for a few months. Consistency helps to foster a faithful following.

## How do you support each other in the work you do together and the interests you have beyond Food Heaven Made Easy?

WENDY: We were friends before we decided to create a business together, which has been tremendously helpful. We are able to recognize our strengths and limitations, which is useful when deciding who handles what. I have an eye for visuals and design, so I do most of the recipe

development and photography. Jess has experience in journalism, so she handles a lot of the nutrition articles for the site. She's also great with business planning and marketing, so she handles all that fun stuff as well. Although we sometimes bump heads as business partners, we know that we're on the same team, so we always reach common ground. We also have clear boundaries as business partners and friends. Once business is handled, we kick it as sister friends. We watch movies, go out to eat, talk about life, and travel. This keeps the bond strong and also gives us downtime from the business madness.

## How has your tribe (family, friends, virtual community, and so on) supported you through your journey of building Food Heaven Made Easy?

**JESS:** We can genuinely say we have the best tribe in the world! No, but really, any time we need anything, our friends and family are there to help out with the cause. The best part is that most of them have been there from day one—filming our videos or lending space to throw events. Anytime there is a Food Heaven milestone, our community sends emails and messages letting us know how proud they are, which means the world. We have so many friends who also lend us a space to stay whenever we need it. For example, we just went to a nutrition conference in Boston, and one of our tribe members was totally down to host us and make her space our home for the time. Our Food Heaven community is everything. It is so inspiring how they let us into their lives and try all the recipes we create and our nutrition suggestions. We are truly blessed.

## Do you have any tips or suggestions for building a creative community online?

**JESS:** The first step is figuring out what kind of community you want to create. Try to be as specific as possible so that the content you create is relevant and useful to your people. Visualize what kind of members you will have and even consider writing down some of their characteristics. If we were to write down our reader, she (our readers are 99 percent female) would be a healthy woman who is strapped for time and wants to eat healthier, but not spend hours in the kitchen. She wants her meals simple, flavorful, and cost-effective. Who is your tribe?

Also make sure you reach out to people who have experience in building the kind of online community you envision. If you're interested in creating an online meditation space, reach out to people who are doing that kind of work and have more experience than you. There's literally someone doing just about everything nowadays online. We've been surprised at how open people have been when we simply ask for guidance.

# Acknowledgments

I would like to express my deep gratitude to the following people who have supported and encouraged me through this project: Bridget Watson Payne, Samir Bhur, and my beautiful parents.

A great big hug and thank you to the contributors who took time to share their stories: Neha Agarwal, Laura Ash, Lisa Nicole Bell, Sola Biu, e Bond, Jessica Caldwell, Maurice Cherry, B. Cole, Danielle Finney, Mavis Gragg, Nicole Haddad, Maori Karmael Holmes, Jamala Johns, Jessica Jones, Wendy Lopez, Bernardo Margulis, Maeling Murphy, De Nichols, Aisha Pew, Justin Shiels, Gabi Smith, Jessica Solomon, Sarah Walsh, Lorraine West, Hadiya Williams, and Shelley Worrell.

Lastly, I would like to say thank you to my social media tribe. From the blog and artwork to my books, you have supported my creative ventures and I appreciate every share, every mention, and every message. You keep me inspired and for that I am forever grateful. Thank you for being a part of my dream.

# CONTRIBUTOR CREDITS

## CHAPTER 1:
## We Inspire Me

**Gabi Smith**
heygabi.com
iamthenublack.com

**Nicole Haddad**
lobomau.com

**Bernardo Margulis**
thismakesmehappy.co
thehappypodcast.com

**Lorraine West**
lorrainewestjewelry.com

## CHAPTER 2:
## Your Career Circle

**Maori Karmael Holmes**
blackstarfest.org

**Sola Biu**
solabiu.com

**Hadiya Williams**
hadiyawilliams.com
blackpepperpaperie.com

**Lisa Nicole Bell**
lisanicolebell.com
*Reference photo credit: Jamaal Murray*

## CHAPTER 3:
## Being Social & Having Fun

**Jessica Caldwell**
jessdcaldwell.com

**Justin Shiels**
justinshiels.com

**Mavis Gragg**
gragglawfirm.com

**Dian Holton**
dianholton.com

## CHAPTER 4:
## Activate Your Community

**Jessica Solomon**
artinpraxis.org

**De Nichols**
deandreanichols.com

**B. Cole and Aisha Pew**
brioxy.com
dovecotecafe.com

## CHAPTER 5:
## Take Care of Yourself/
## Take Care of Each Other

**e Bond**
ebondwork.com

**Danielle Finney**
dfinneyphoto.co

**Lauren Ash**
blackgirlinom.com

## CHAPTER 6:
## Be Culture Curious

**Maurice Cherry**
mauricecherry.com
revisionpath.com

**Neha Agarwal**
nehaagarwal.com

**Shelley Worrell**
caribbeing.com
worrellmediagroup.com

## CHAPTER 7:
## Your Virtual Friends

**Jamala Johns**
jamalajohns.com

**Maeling Murphy**
naturalchica.com

**Sarah Walsh**
sarahwalshmakesthings.com

**Wendy Lopez and Jessica Jones**
foodheavenmadeeasy.com
*Reference photo credit: Bitnara Shin*

WE
INSPIRE
ME